Georgia O'Keefe Coloring Book

By Camilla Starfire

This book contains 18 colorable images Georgia O'Keefe paintings in gray scale. These images are best colored with colored pencil.
There are two ways to color gray scale images. The easiest way is to simply color over the images lightly allowing some of the underlying shading to show through.

For the portrait images, lightly color over the faces and other areas of skin with a flesh colored pencil. Then color over the clothes and background with the colors of your choice.

The second way of coloring the painting images is a little more challenging. You can blend the lighter and darker areas e with lighter and darker colored pencils using the underlying light and dark of the print as a guide. Many of the painting images can be colored with your choice of colors. I have lightened some of the images so that the colored pencils will look brighter.

Please note: Where I have found information about the individual paintings, it will be on the back of their photo. I thought you might want to separate the pages from the book, and that way the information will be with that photo.

I have also included quotations by this fascinating artist which may give you a little insight into her personality.

Georgia Totto O'Keeffe (November 15, 1887 – March 6, 1986) was an American artist. She is best known for her paintings of enlarged flowers, New York skyscrapers, and New Mexico landscapes. O'Keeffe has been recognized as the "Mother of American Modernism.

After studying at the School of the Art Institute of Chicago she attended the Art Students League in New York, studying under William Merritt Chase. Though she impressed the league with her oil painting "Dead Rabbit with Copper Pot," she lacked self-confidence and decided to pursue a career as a commercial artist and later as a teacher and then head of the art department at West Texas A&M University. At that time she became acquainted with a landscape that would become iconic within her work, the Palo Duro Canyon. O'Keeffe did not stop producing charcoal drawings and watercolors during her hiatus, some of which were seen by Alfred Stieglitz, her future husband. Stieglitz was a successful photographer and modern art promoter who owned the 291 Gallery in New York City. He was struck by the sincerity within her work and organized her first solo show in 2017, composed of oil paintings and watercolors completed in Texas.

Many claim that the images which Georgia O'Keeffe created when painting flowers, was work which was highly sexual, and many went as far as to say it was an erotic art form; but O'Keeffe rejected that theory consistently. In an attempt to move the attention of her critic's away from their Freudian interpretations of her work, she began to paint in a more representational style. In her series on New York, O'Keeffe excelled in painting architectural structures as highly realistic and expertly employed the style of Precisionism within her work. "Radiator Building-Night, New York" from 1927 can also be interpreted as a double portrait of Steiglitz and O'Keeffe. Object portraiture of this kind was popular amongst the Steiglitz circle at the time and greatly influenced by the poetry of Gertrude Stein.

In 1929, seeking solitude and an escape from a crowd that perhaps felt artistically and socially oppressive, O'Keeffe traveled to New Mexico and began an inspirational love affair with the visual scenery of the state. For 20 years she spent part of every year working in New Mexico, becoming increasingly interested in the forms of animal skulls and the southwest landscapes. Though it may be the most recognizable style of O'Keefe's that collected the large price, her varied body of work shows much more variety than the one style she's most known for. Within her work and life, O'Keeffe was unapologetically true to her own vision. When she did attempt to supersede her intuition to complete hired work, she became troubled and always retreated back to what felt familiar and natural. She remains one of the most important and innovative artists of the twentieth century.

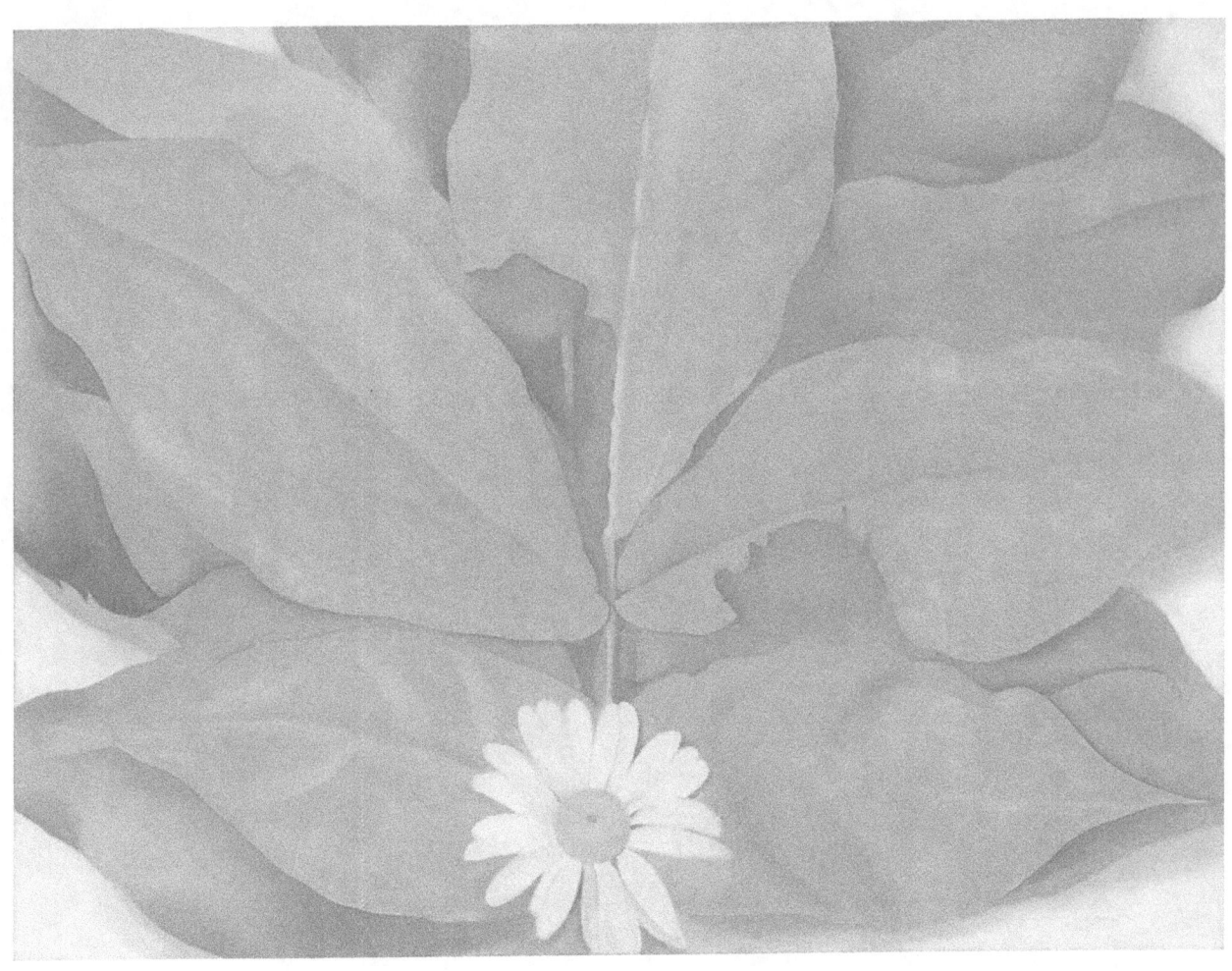

Yellow Hickory Leaves with Daisy, 1928

"I've been absolutely terrified every moment of my life and I've never let it keep me from doing a single thing that I wanted to do." — Georgia O'Keefe

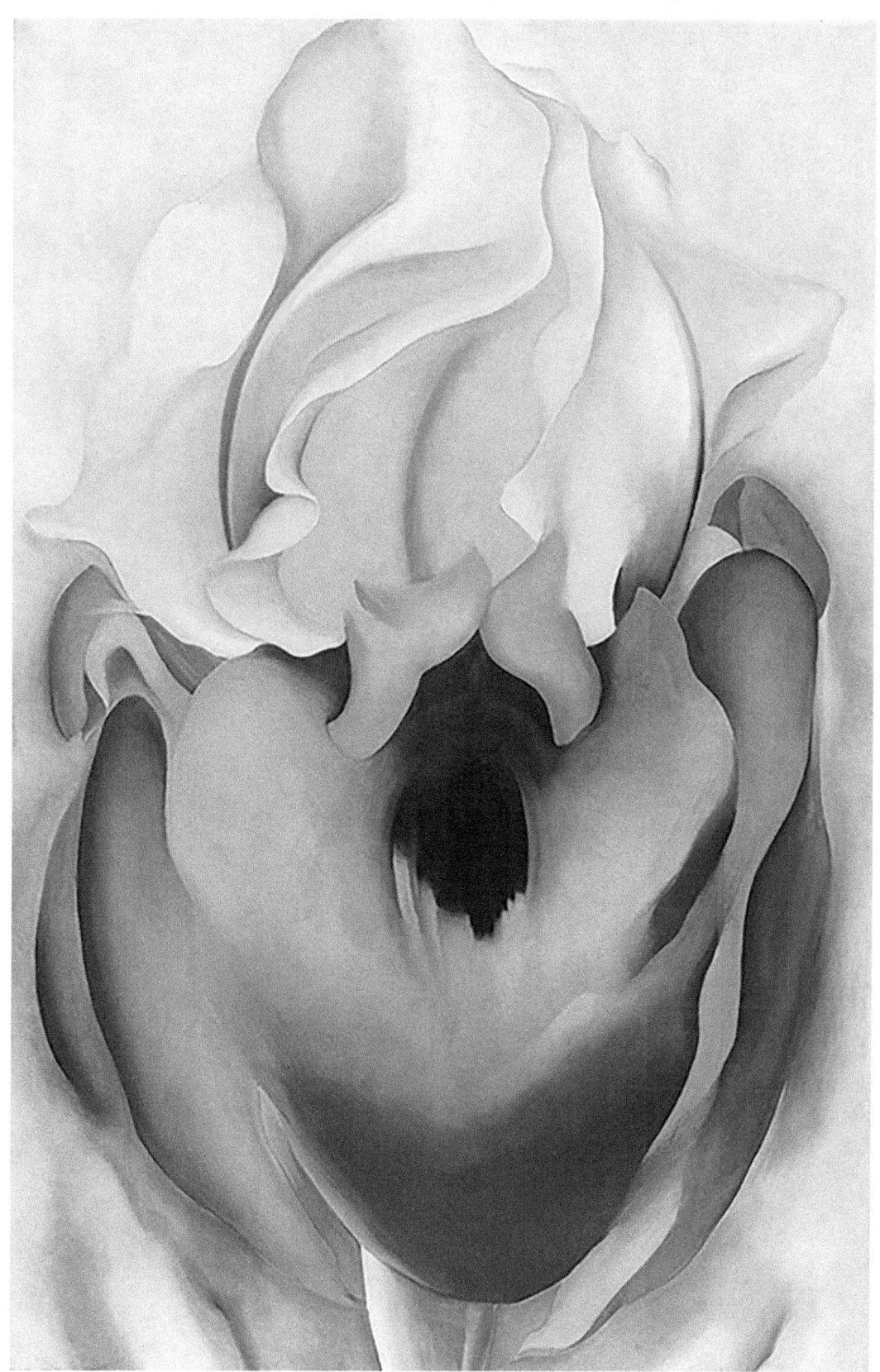

Black Iris VI, 1936.

"If you take a flower in your hand and really look at it, it's your world for a moment." —Georgia O'Keefe

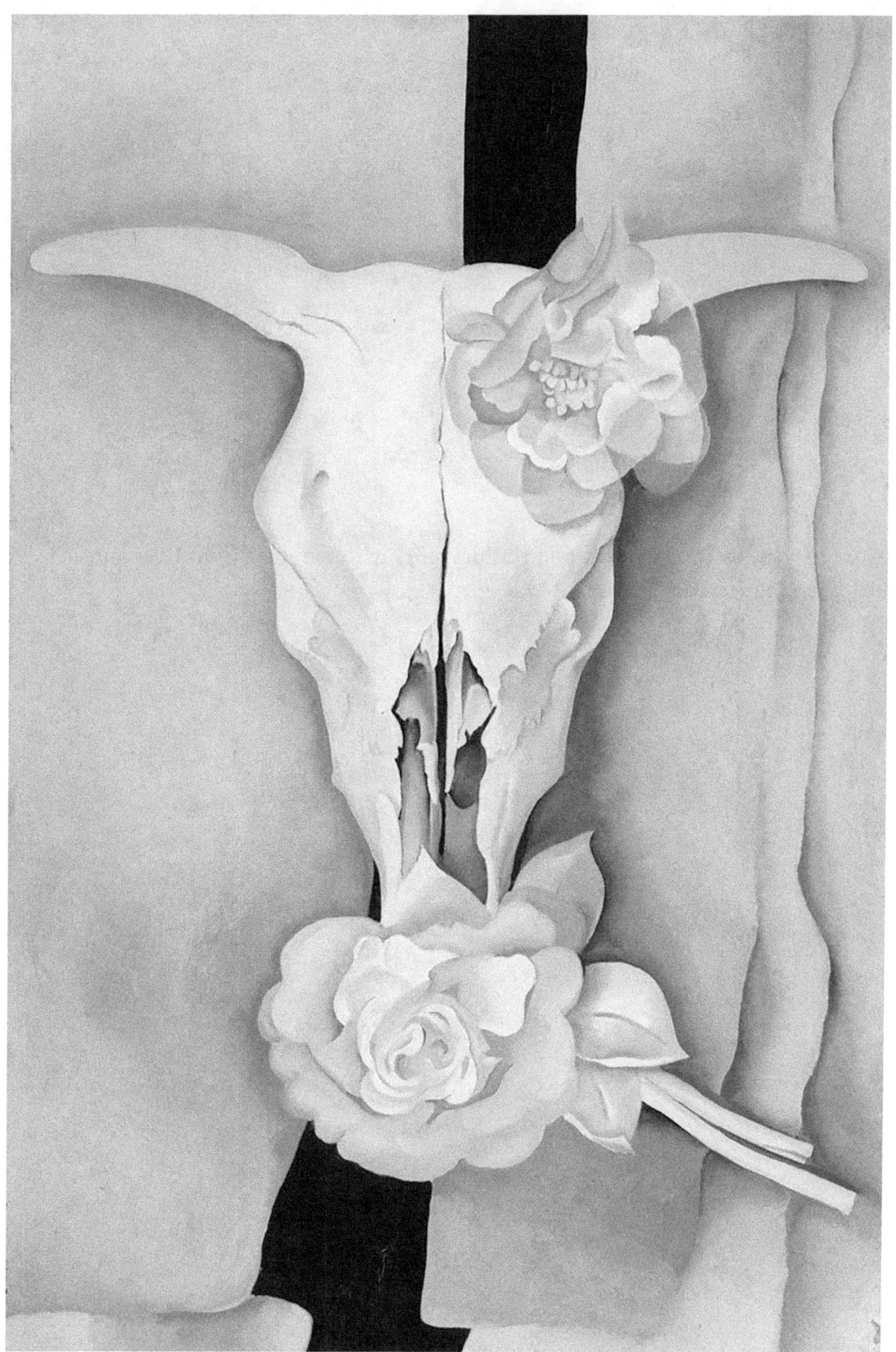

Cow's Skull with Calico Roses. 1931.

"I have already settled it for myself so flattery and criticism go down the same drain and I am quite free." -Georgia O'Keefe

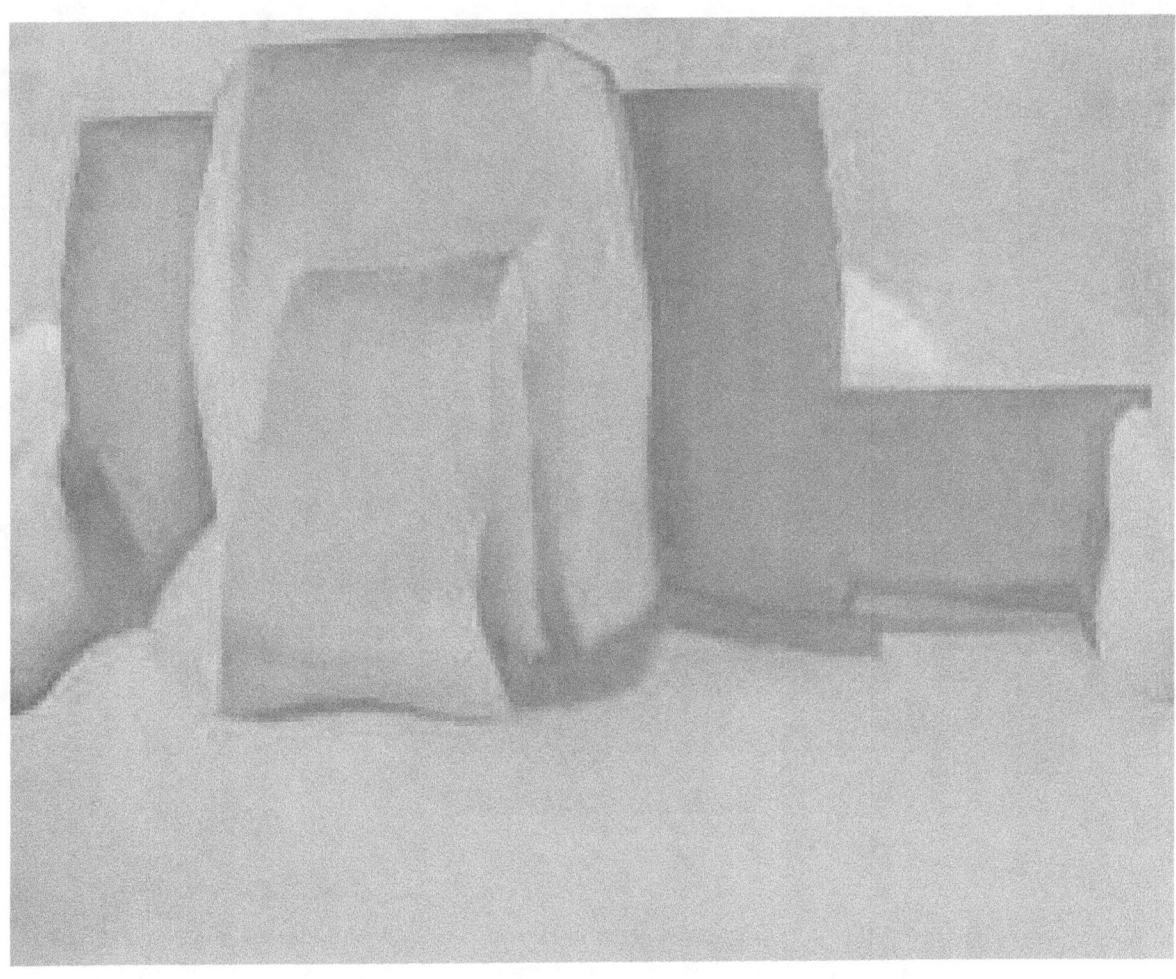

Ranchos Church New Mexico, 1930.

"Whether you succeed or not is irrelevant, there is no such thing. Making your unknown known is the important thing--and keeping the unknown always beyond you." -Georgia O'Keefe

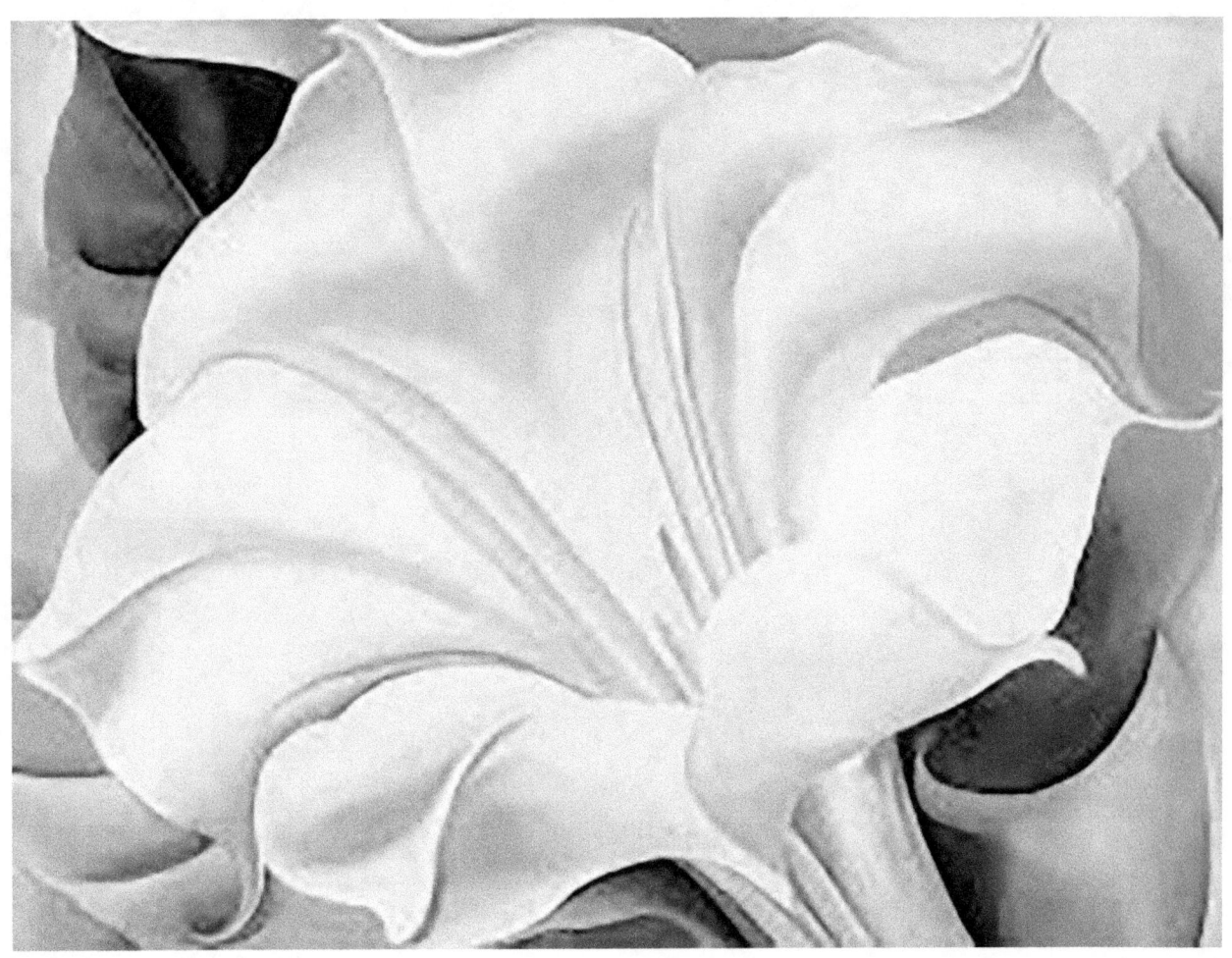

White Trumpet Flower, 1932.

"I found I could say things with color and shapes that I couldn't say any other way... things I had no words for. -Georgia O'Keefe

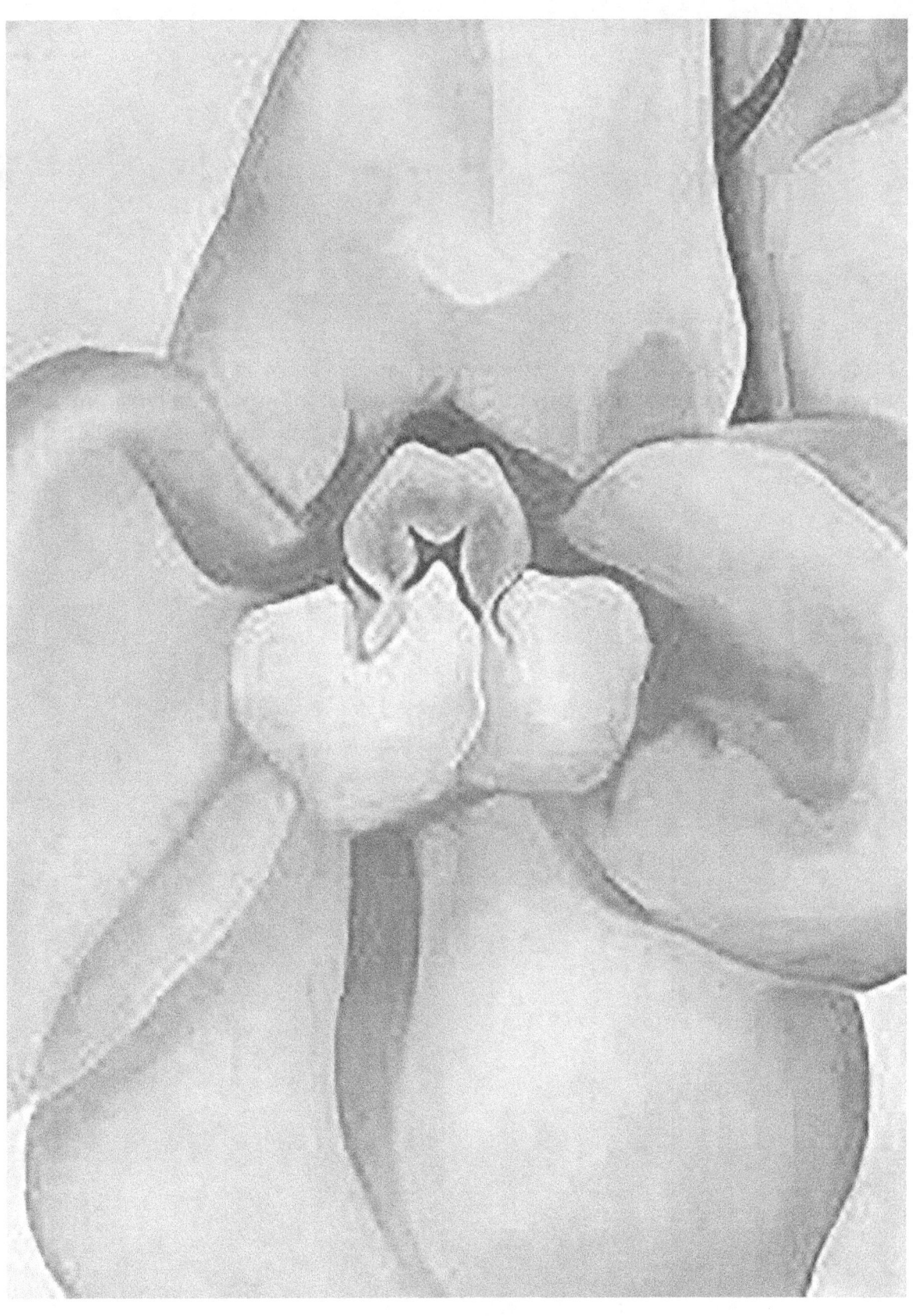

Blue Flower.

"I think it's so foolish for people to want to be happy. Happy is so momentary-you're happy for an instant and then you start thinking again. Interest is the most important thing in life; happiness is temporary, but interest is continuous." -Georgia O'Keefe

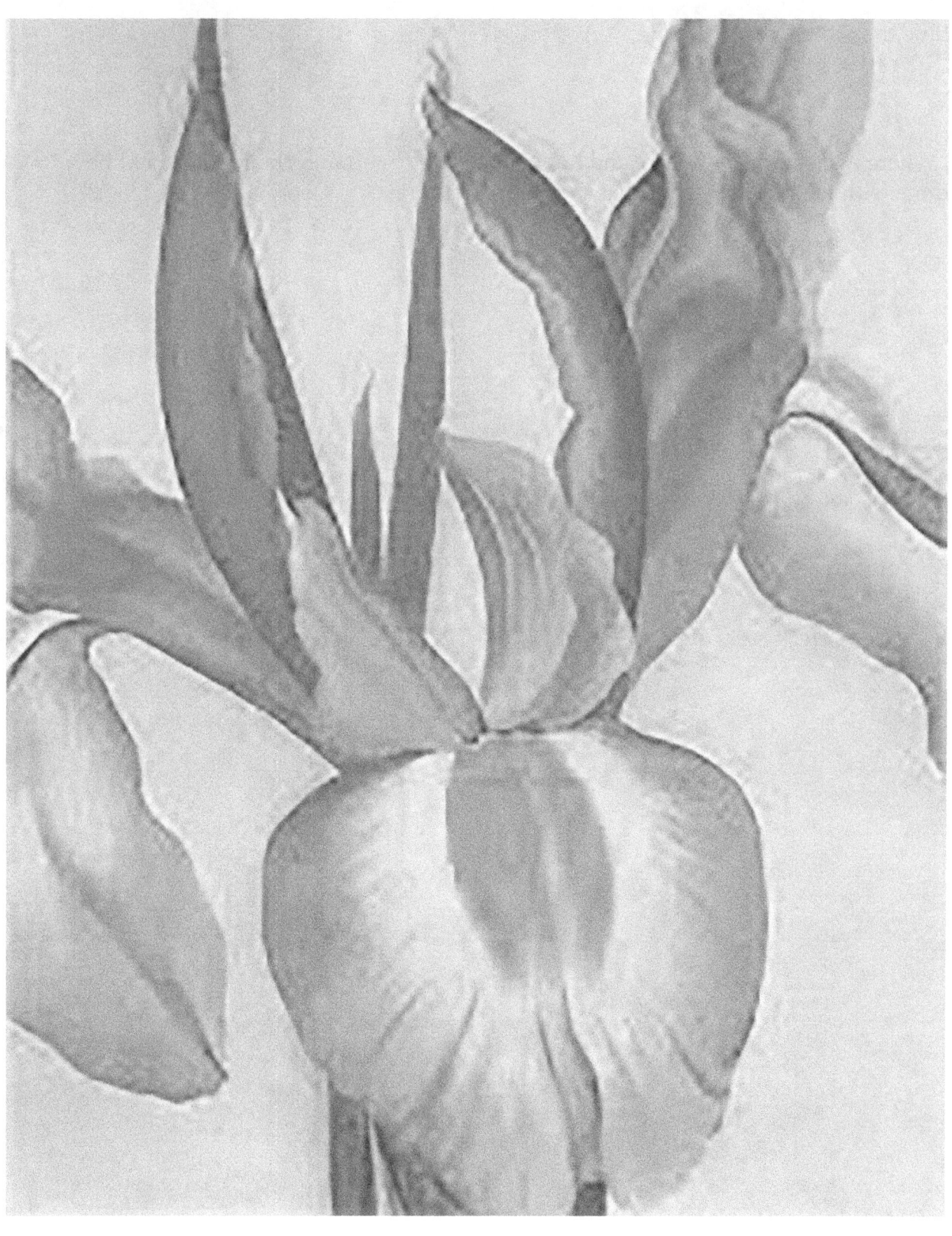

Blue Iris.

"Where I was born and where and how I have lived is unimportant. It is what I have done with where I have been that should be of interest." —Georgia O'Keefe

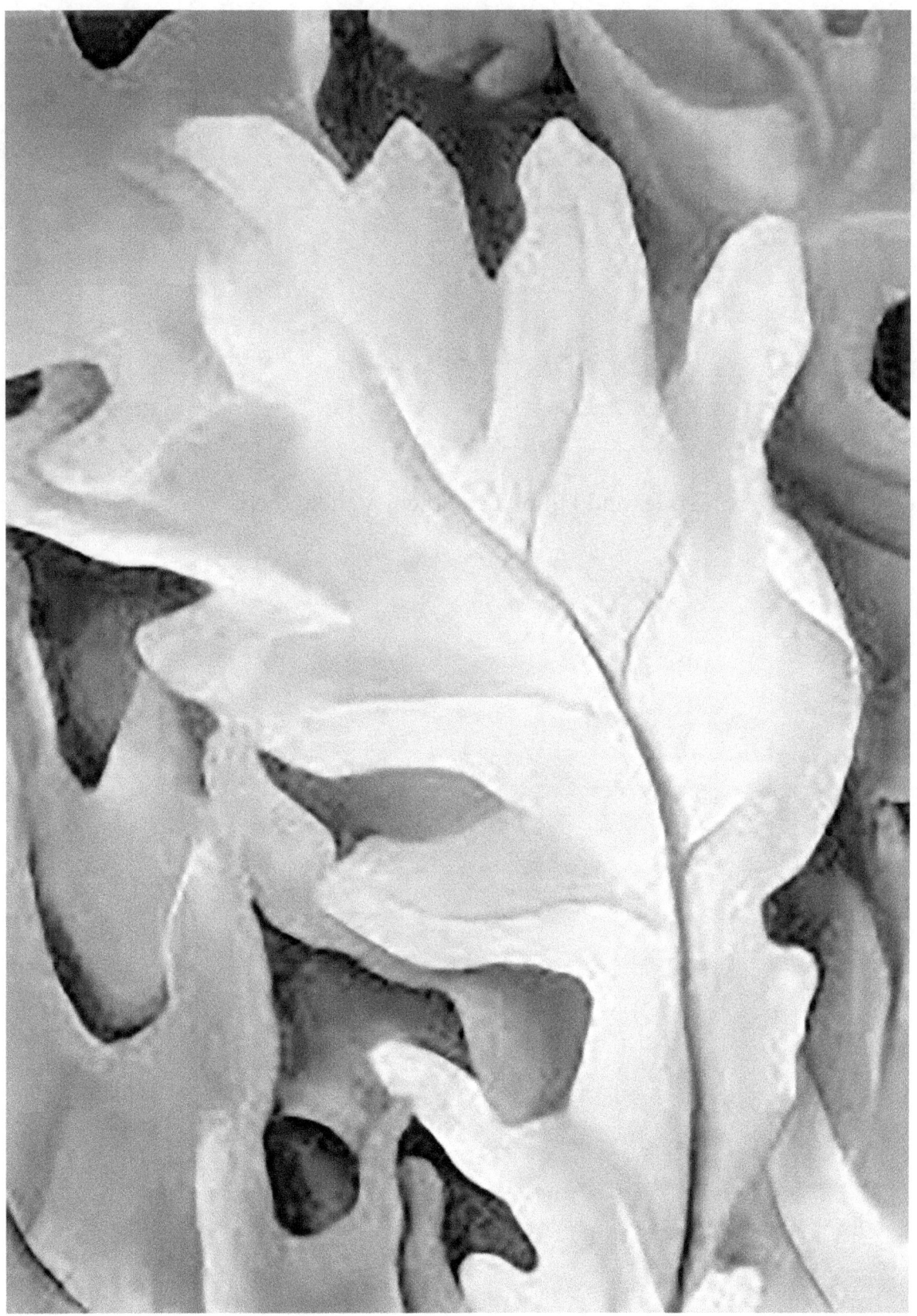

Purple Leaves.

"I wish people were all trees and I think I could enjoy them then." —Georgia O'Keefe

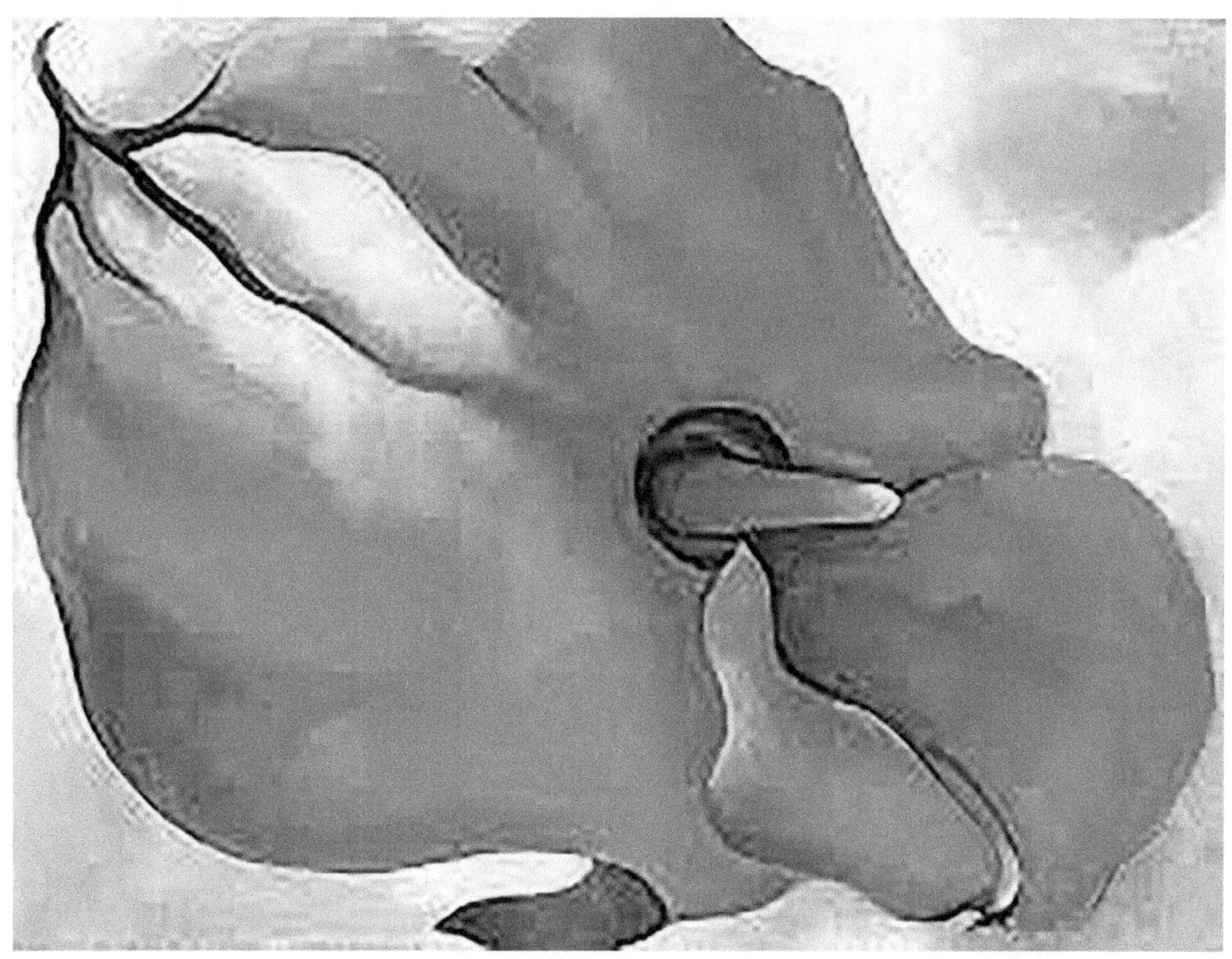

Yellow Calla.

"To create one's world in any of the arts takes courage." -Georgia O'Keefe

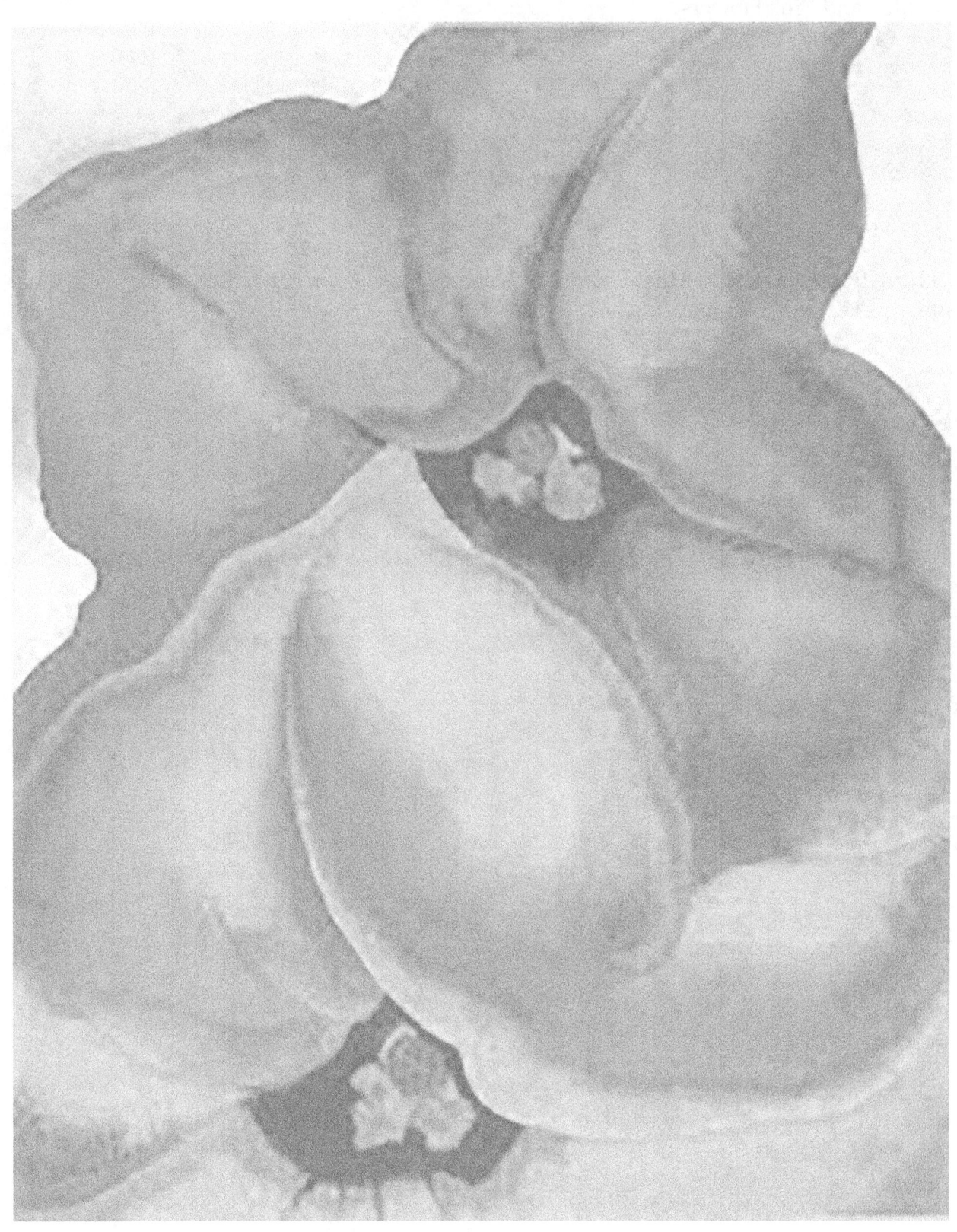

Blue and Pink Flowers.

"I have things in my head that I have no reference for in the real world."-
Georgia O'Keefe

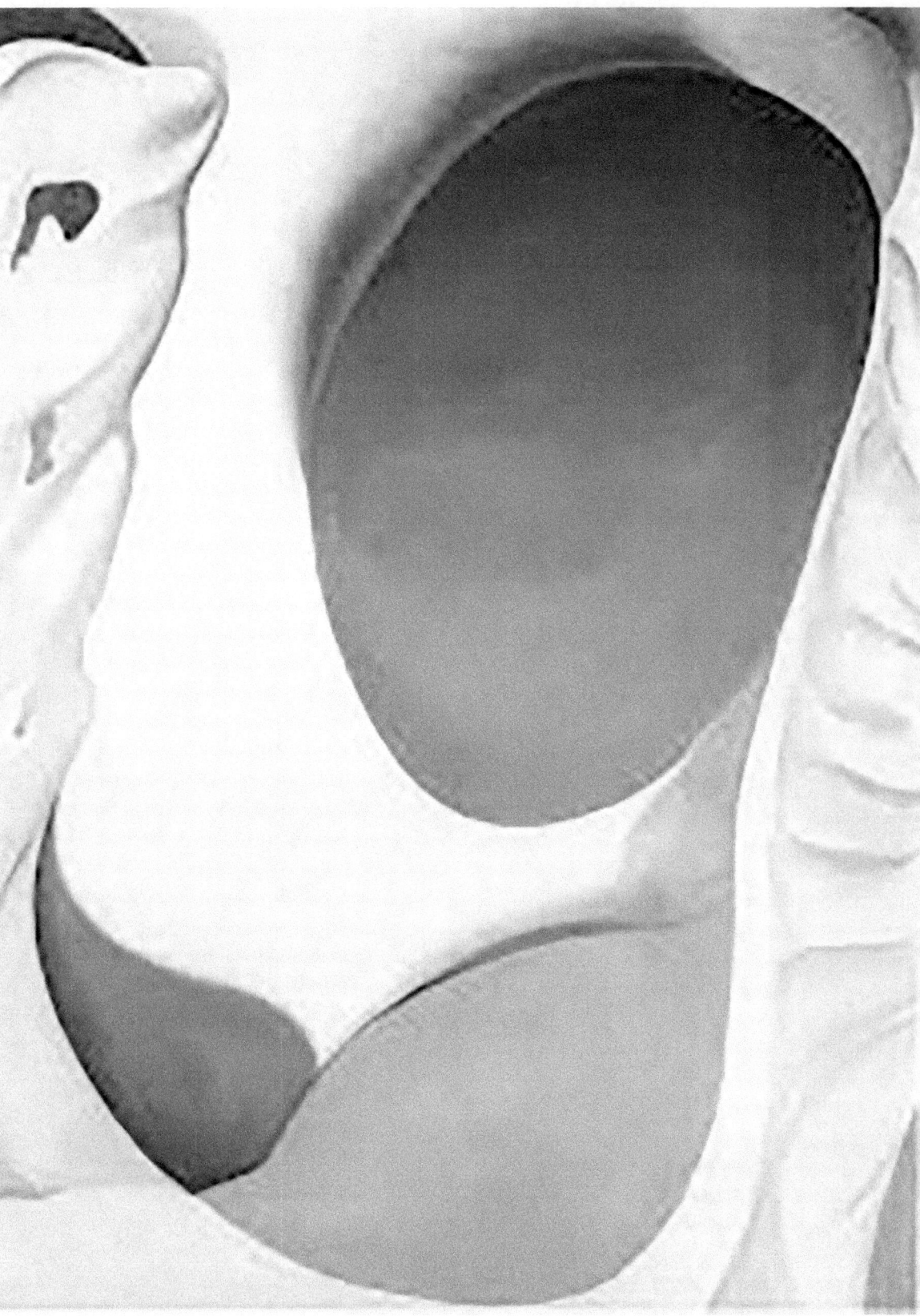

Sky and Pelvic Bone.

"I can't live where I want to, I can't go where I want to go, I can't do what I want to, I can't even say what I want to. I decided I was a very stupid fool not to at least paint as I wanted to." -Georgia O'Keefe

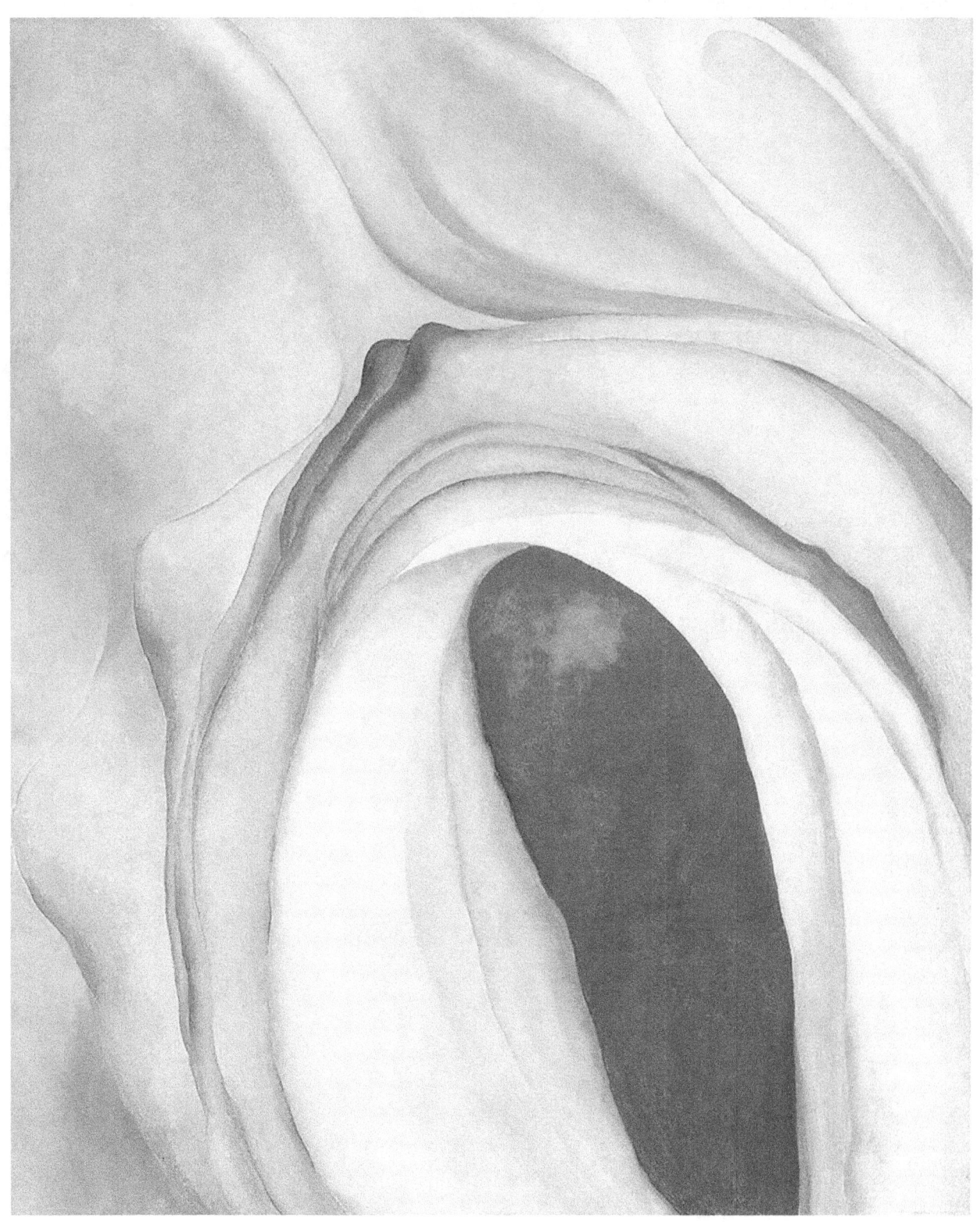

Pink and Blue Music, No. 2, 1918.

"I decided to accept as true my own thinking." -Georgia O'Keefe

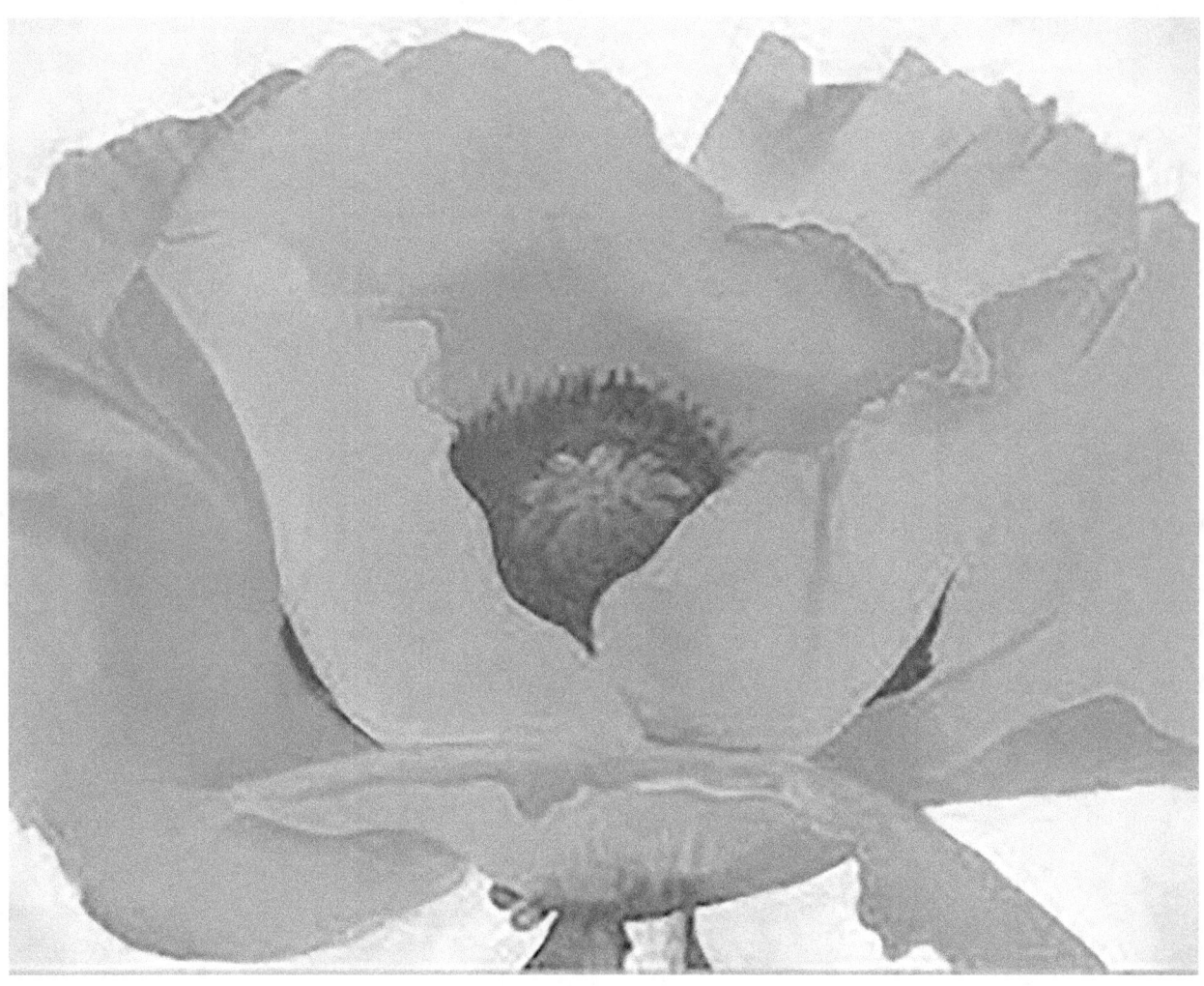

Oriental Poppy.

"Nothing is less real than realism. Details are confusing. It is only by selection, by elimination, by emphasis, that we get at the real meaning of things." -Georgia O'Keefe

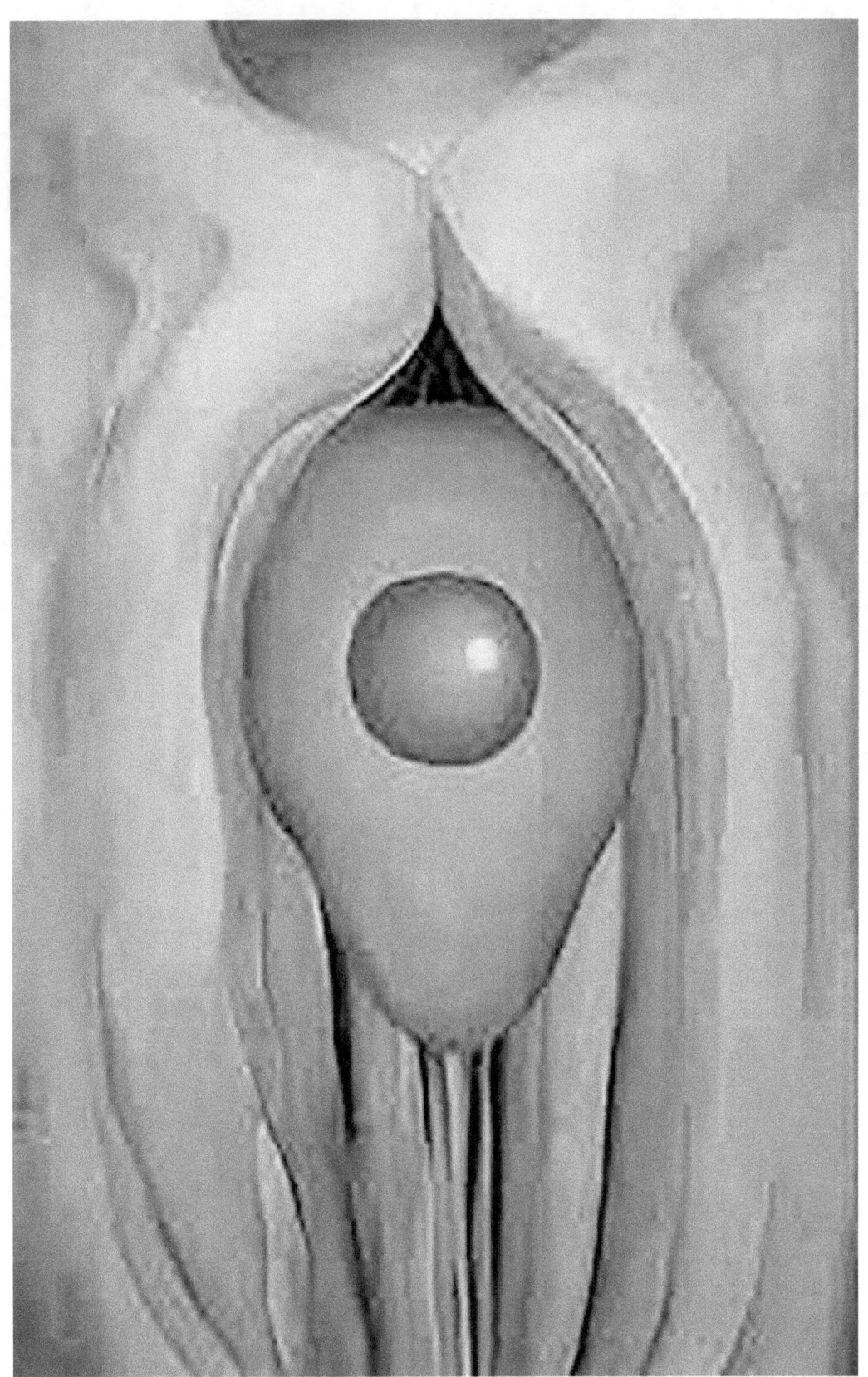

Avocado Half.

It's not enough to be nice in life. You've got to have nerve." -Georgia O'Keefe

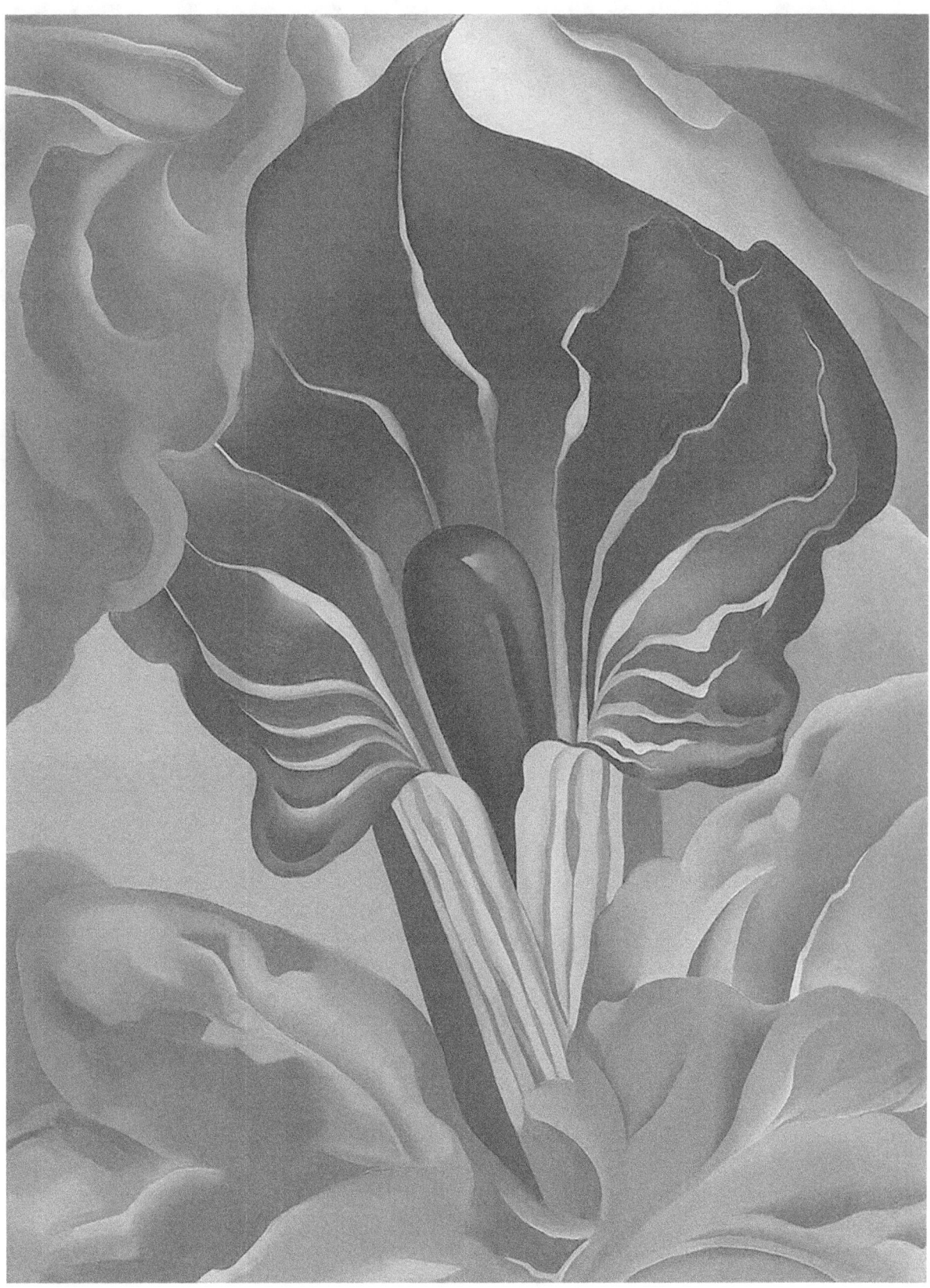

Jack-in-Pulpit, No. 2, 1930.

"I often painted fragments of things because it seemed to make my statement as well as or better than the whole could." -Georgia O'Keefe

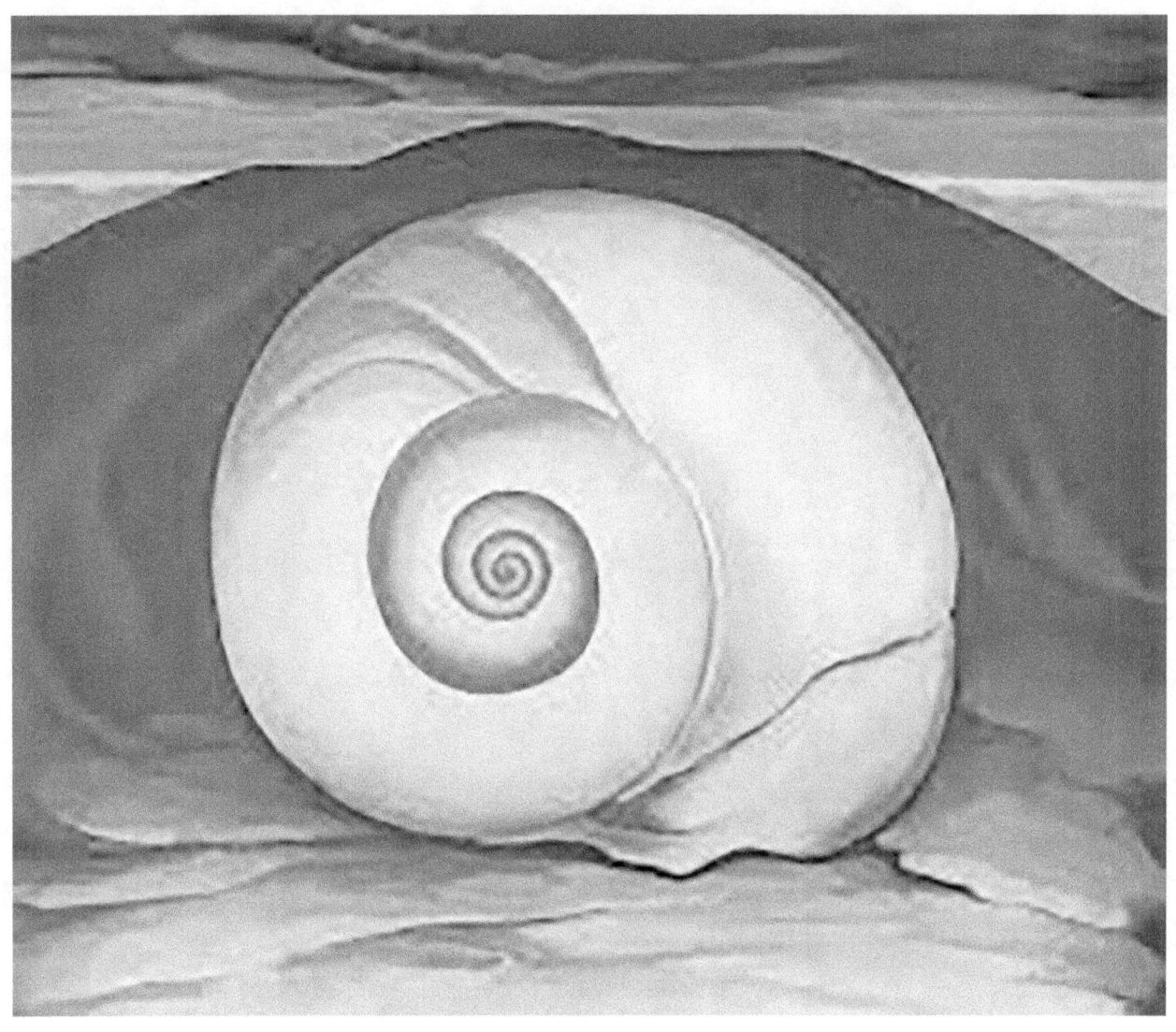

Red Hills and White Snail, 1938.

"Someone else's vision will never be as good as your own vision of yourself. Live and die with it 'cause in the end it's all you have. Lose it and you lose yourself and everything else. I should have listened to myself." — Georgia O'Keefe

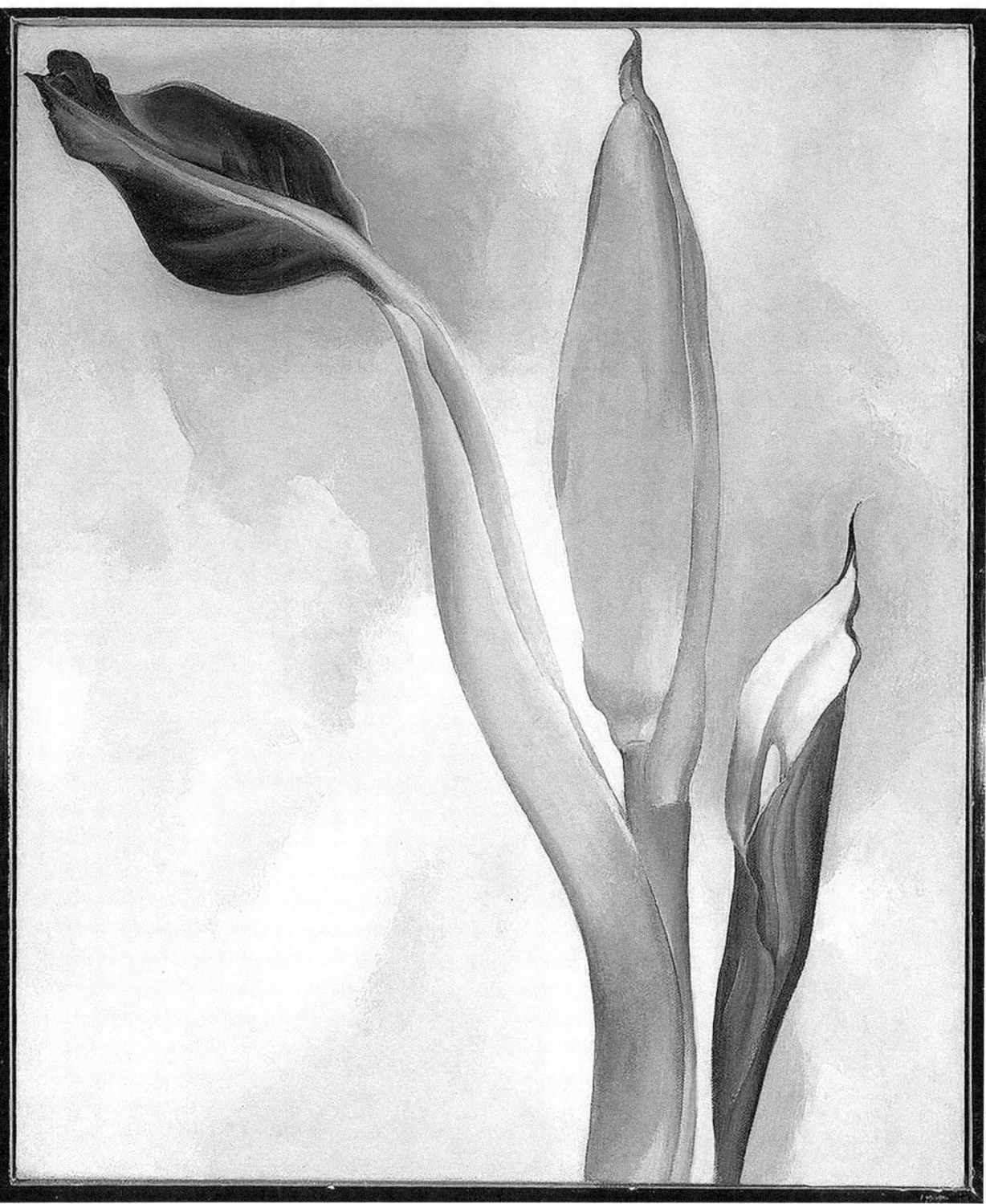

Pink Ornamental Banana, 1938.

"I made you take time to look at what I saw and when you took time to really notice my flower, you hung all your associations with flowers on my flower and you write about my flower as if I think and see what you think and see— and I don't." —Georgia O'Keefe

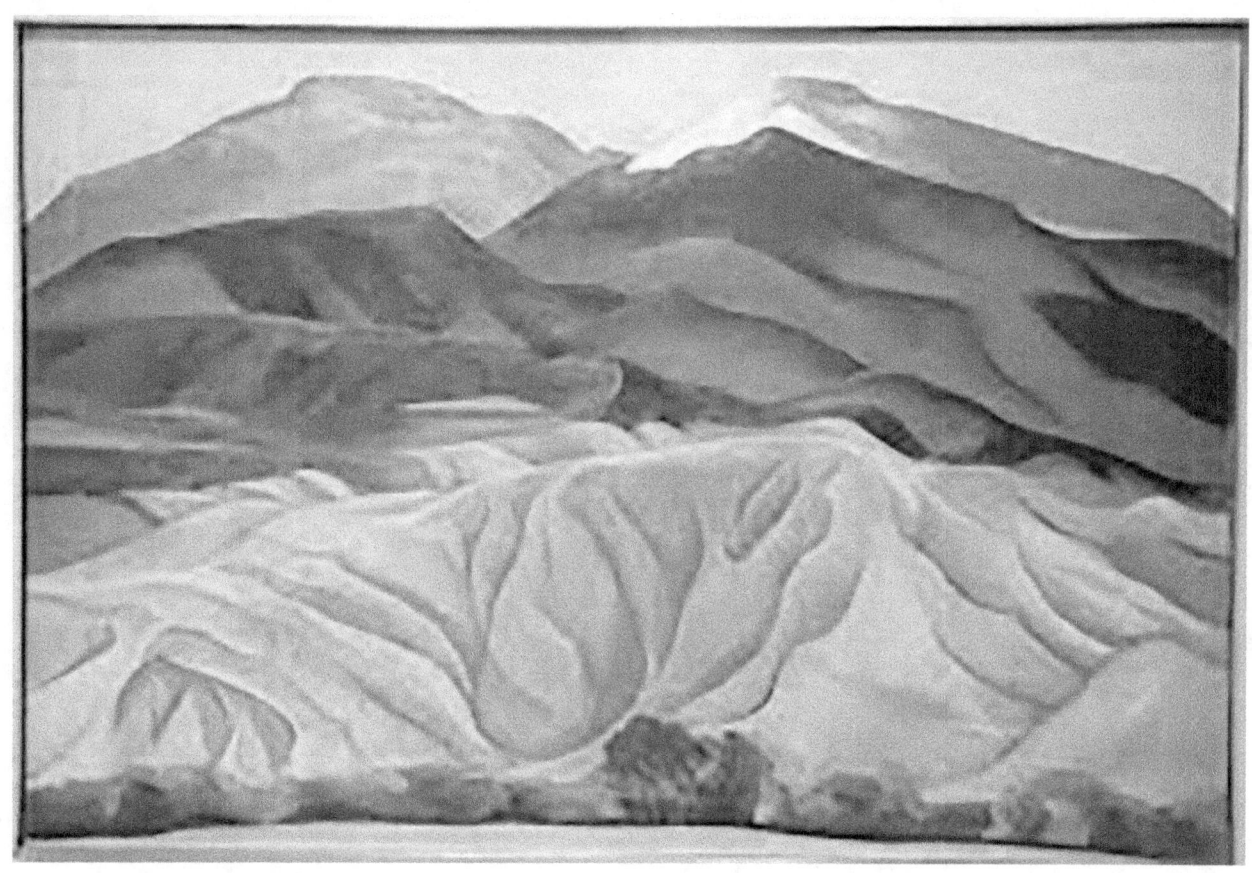

Landscape, New Mexico.

"The days you work are the best days."- Georgia O'Keeffe

"When I look over the photographs Stieglitz took of me-some of them more than sixty years ago-I wonder who that person is. It is as if in my one life I have lived many lives. If the person in the photographs were living in this world today, she would be quite a different person-but it doesn't matter Stieglitz photographed her then." — Georgia O'Keefe

www.ingramcontent.com/pod-product-compliance
Lightning Source LLC
Chambersburg PA
CBHW080611190526
45169CB00007B/2970